The Christmas Story

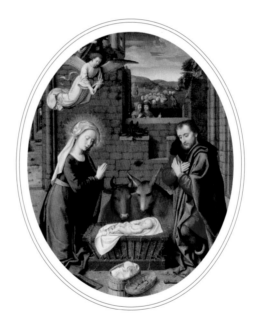

FROM THE

GOSPELS OF MATTHEW AND LUKE

THE METROPOLITAN MUSEUM OF ART

ABRAMS BOOKS FOR YOUNG READERS

NEW YORK

Published by The Metropolitan Museum of Art, New York, and Abrams Books for Young Readers,
an imprint of Harry N. Abrams, Inc.
Copyright © 2009 The Metropolitan Museum of Art

Produced by the Department of Special Publications, The Metropolitan Museum of Art:
Robie Rogge, Publishing Manager; Jessica Schulte, Project Editor; Atif Toor, Designer; Victoria Gallina, Production Associate.

All photography by The Metropolitan Museum of Art Photograph Studio.

First Edition
Printed in China
18 17 16 15 14 13 12 11 10 09 5 4 3 2 1

The selections from Isaiah and the Gospels of Matthew and Luke are from the King James Version of the Bible.
Extracts from the Authorized Version of the Bible (The King James Bible), the rights in which are vested in the Crown,
are reproduced by permission of the Crown's Patentee, Cambridge University Press.

Library of Congress Cataloging-in-Publication Data

The Christmas story.
 p. cm.
 "In association with the Metropolitan Museum of Art."
 ISBN 978-0-8109-8002-0 (Harry N. Abrams)
 1. Jesus Christ—Nativity—Art—Juvenile literature. 2. Jesus Christ—
Nativity—Juvenile literature. I. Metropolitan Museum of Art (New York, N.Y.)

N8060.C53 2009
755.56074'7471—dc22

 2008046189

ISBN (MMA): 978-1-58839-298-5
ISBN (Abrams): 978-0-8109-8002-0

Visit the Museum's website: www.metmuseum.org

HNA
harry n. abrams, inc.
a subsidiary of La Martinière Groupe
115 West 18th Street
New York, NY 10011
www.hnabooks.com

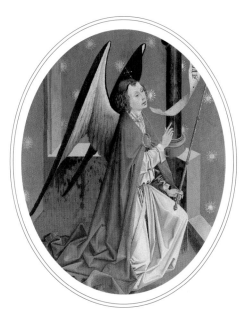

For unto us a child is born, unto us a son is given:

and the government shall be upon his shoulder:

and his name shall be called Wonderful, Counselor,

The mighty God, The everlasting Father,

The Prince of Peace.

—Isaiah 9:6

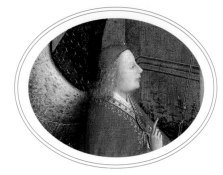

The angel Gabriel was sent from God unto a city of Galilee, named Nazareth, to a virgin espoused to a man whose name was Joseph, of the house of David; and the virgin's name was Mary.

And the angel came in unto her, and said, Hail, thou that art highly favored, the Lord is with thee: blessed art thou among women.

Behold, thou shalt conceive in thy womb, and bring forth a son, and shalt call his name Jesus. He shall be great, and shall be called the Son of the Highest; and the Lord God shall give unto him the throne of his father David: and he shall reign over the house of Jacob forever; and of his kingdom there shall be no end.

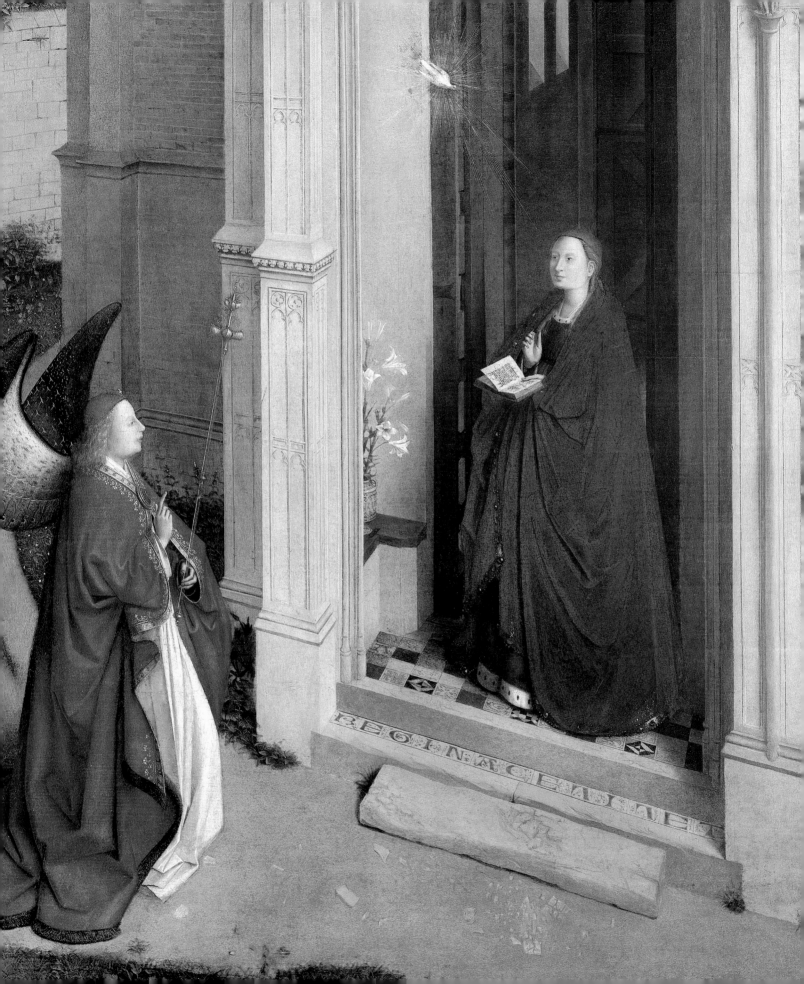

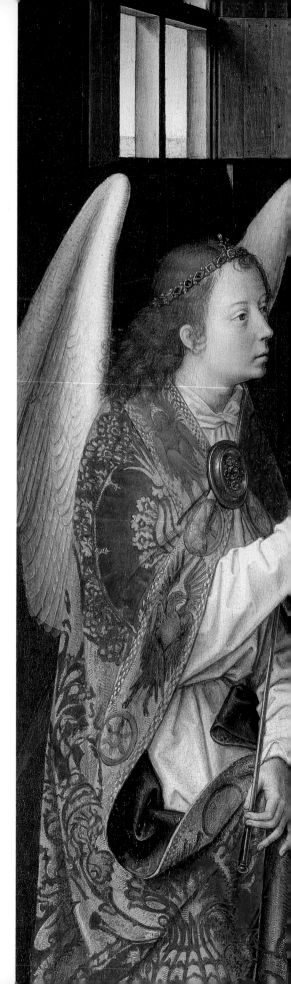

Then said Mary unto the angel, How shall this be, seeing I know not a man? And the angel answered and said unto her, The Holy Ghost shall come upon thee, and the power of the Highest shall overshadow thee: therefore also that holy thing which shall be born of thee shall be called the Son of God.

And Mary said, Behold the handmaid of the Lord; be it unto me according to thy word. And the angel departed from her.

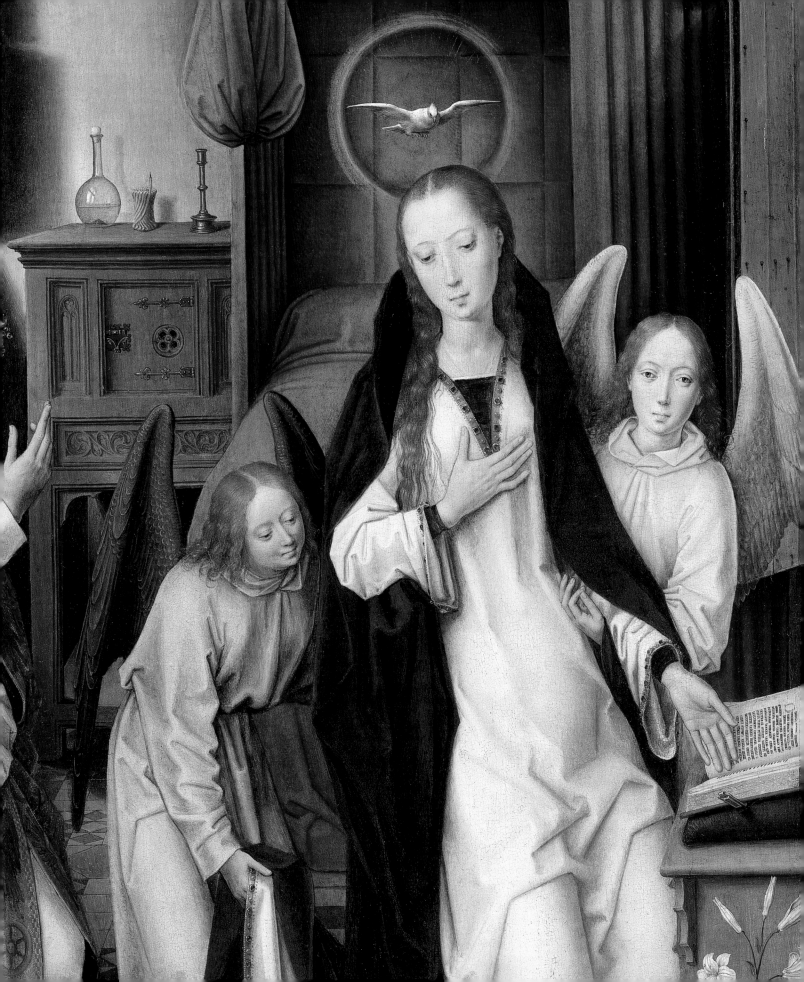

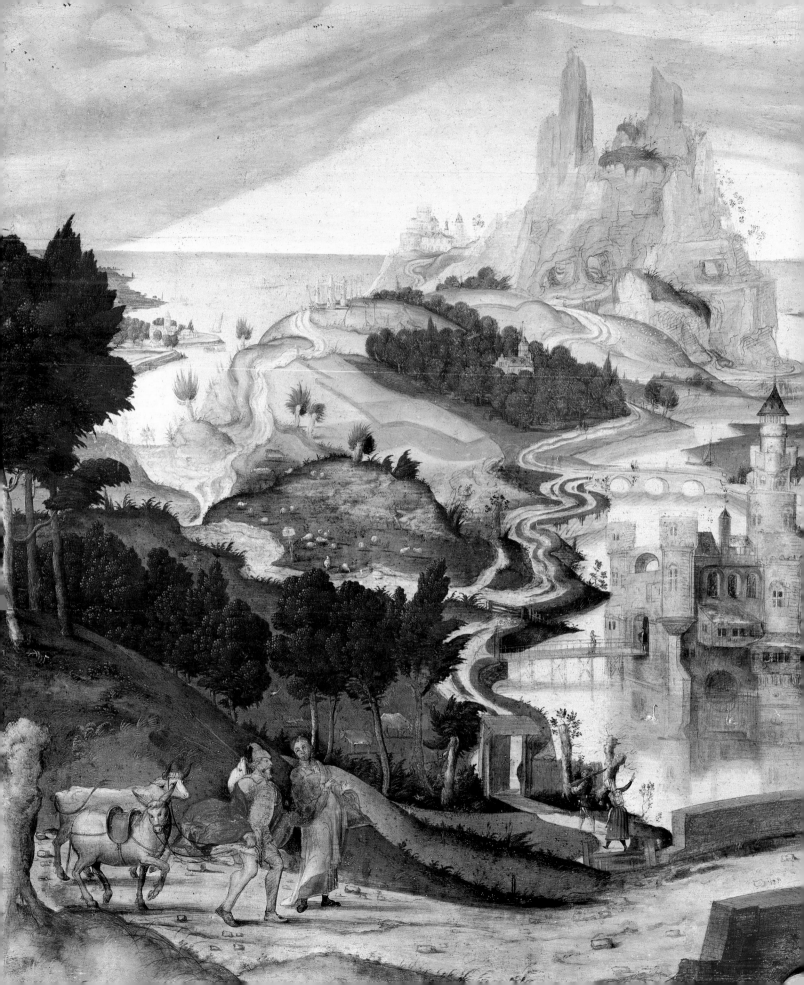

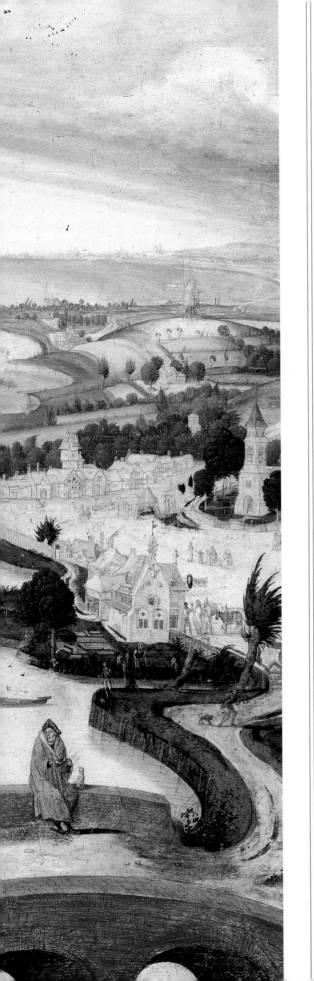

And it came to pass in those days, that there went out a decree from Caesar Augustus, that all the world should be taxed. And all went to be taxed, every one into his own city. And Joseph also went up from Galilee, out of the city of Nazareth, into Judea, unto the city of David, which is called Bethlehem, to be taxed with Mary, his espoused wife, being great with child.

And so it was, that, while they were there, the days were accomplished that she should be delivered. And she brought forth her firstborn son, and she wrapped him in swaddling clothes, and laid him in a manger; because there was no room for them in the inn.

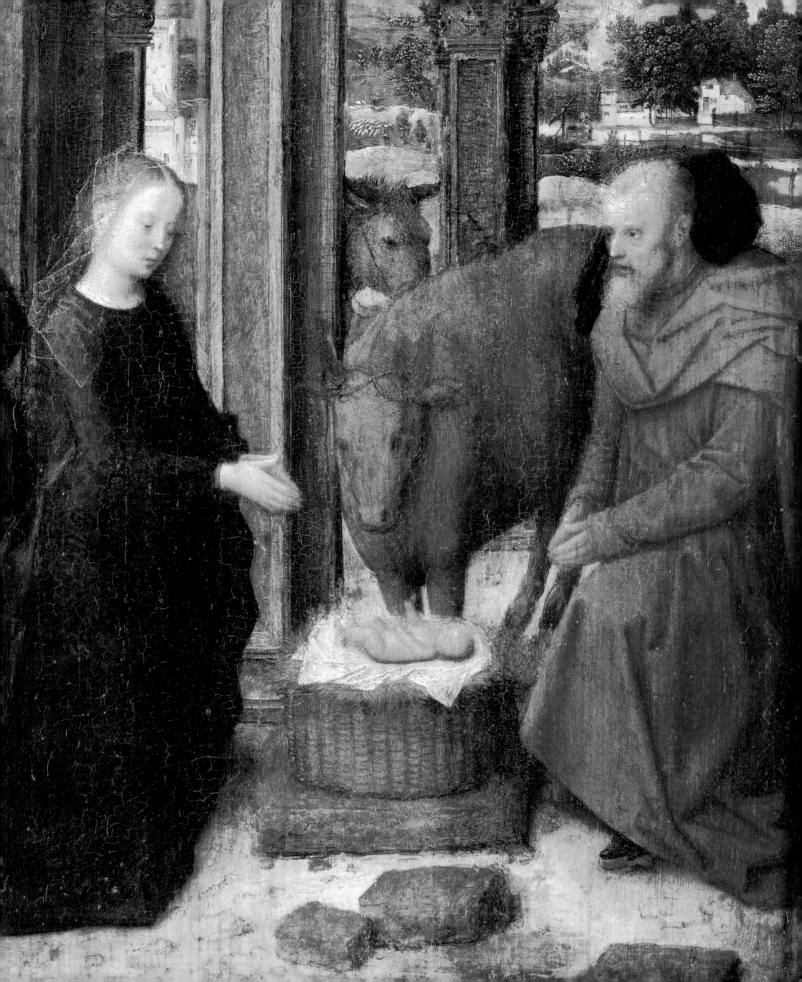

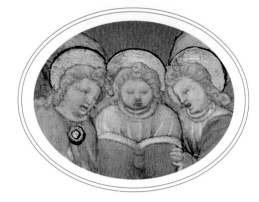

And there were, in the same country, shepherds abiding in the field, keeping watch over their flock by night. And, lo, the angel of the Lord came upon them, and the glory of the Lord shone round about them, and they were sore afraid.

And the angel said unto them, Fear not: for, behold, I bring you good tidings of great joy, which shall be to all people. For unto you is born this day, in the city of David, a Saviour, which is Christ the Lord.

And this shall be a sign unto you; ye shall find the babe wrapped in swaddling clothes, lying in a manger.

And suddenly there was with the angel a multitude of the heavenly host praising God, and saying, Glory to God in the highest, and on earth, peace, good will toward men.

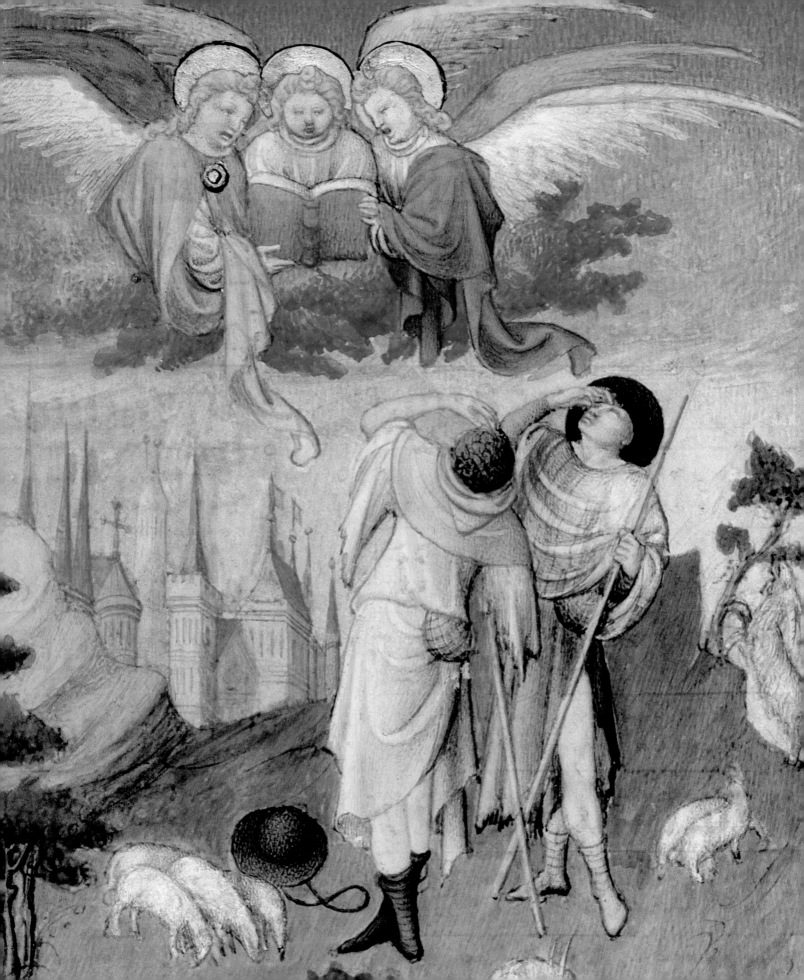

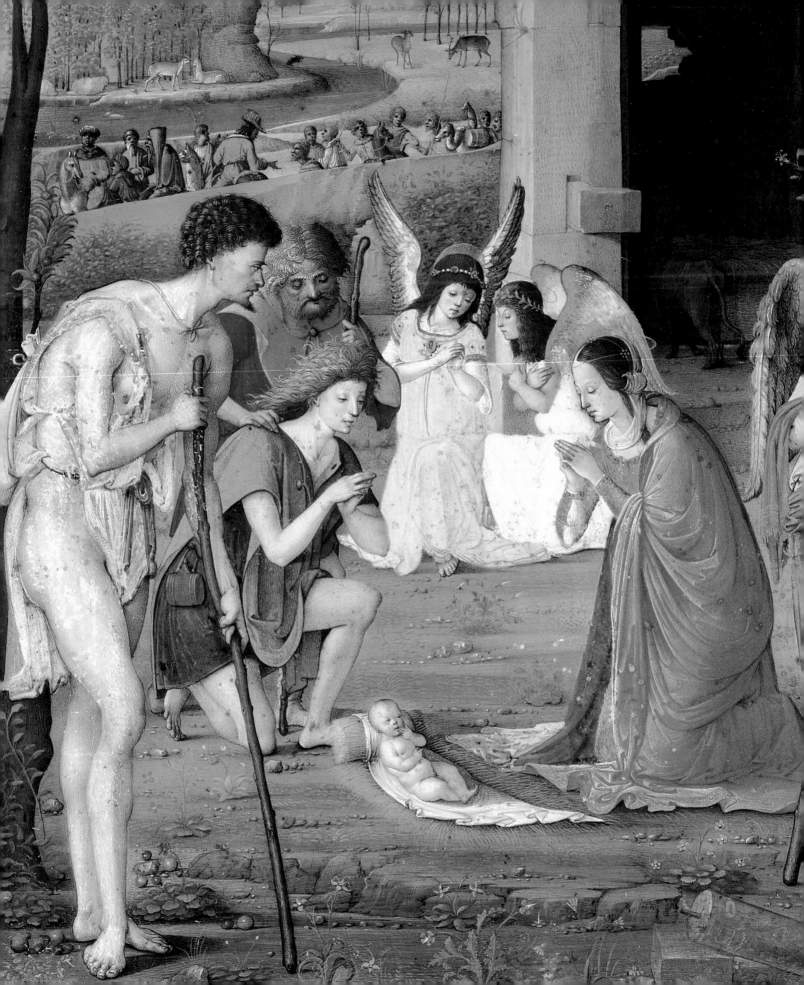

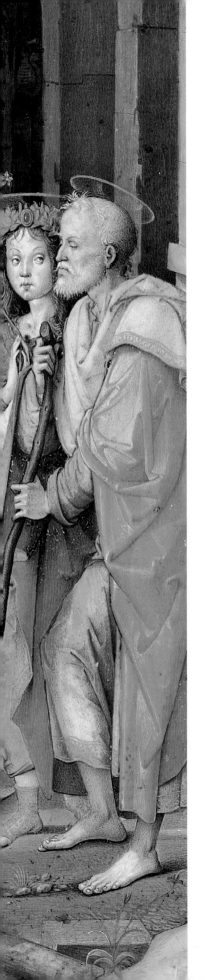

nd it came to pass, as the angels were gone away from them into heaven, the shepherds said one to another, Let us now go even unto Bethlehem, and see this thing which is come to pass, which the Lord hath made known unto us. And they came with haste, and found Mary and Joseph, and the babe lying in a manger.

And when they had seen it, they made known abroad the saying which was told them concerning this child. And all they that heard it wondered at those things which were told them by the shepherds. But Mary kept all these things, and pondered them in her heart.

And the shepherds returned, glorifying and praising God for all the things that they had heard and seen, as it was told unto them.

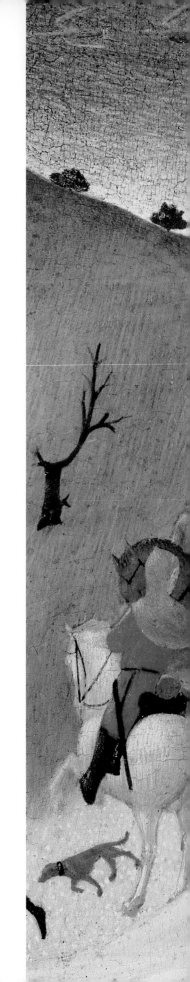

In the days of Herod the king, behold, there came wise men from the east to Jerusalem, saying, Where is he that is born King of the Jews? For we have seen his star in the east, and are come to worship him.

Then Herod inquired of them what time the star appeared. And he sent them to Bethlehem, and said, Go and search diligently for the young child; and when ye have found him, bring me word again, that I may come and worship him also.

When they had heard the king, they departed; and lo, the star, which they saw in the east, went before them, till it came and stood over where the young child was. When they saw the star, they rejoiced with exceeding great joy.

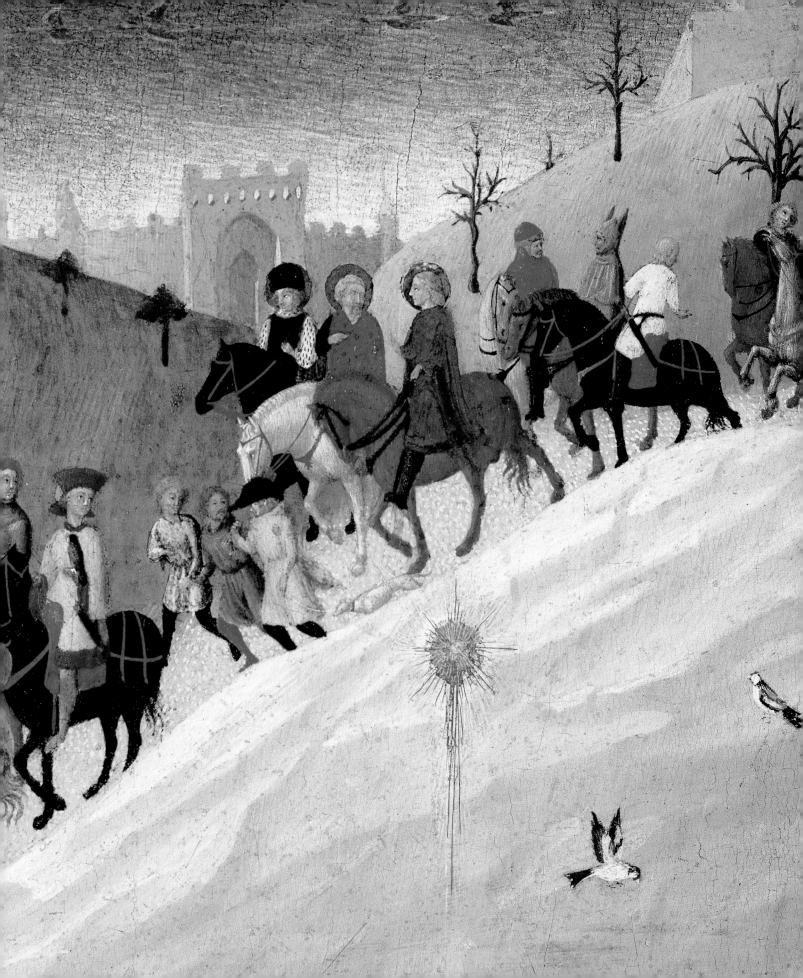

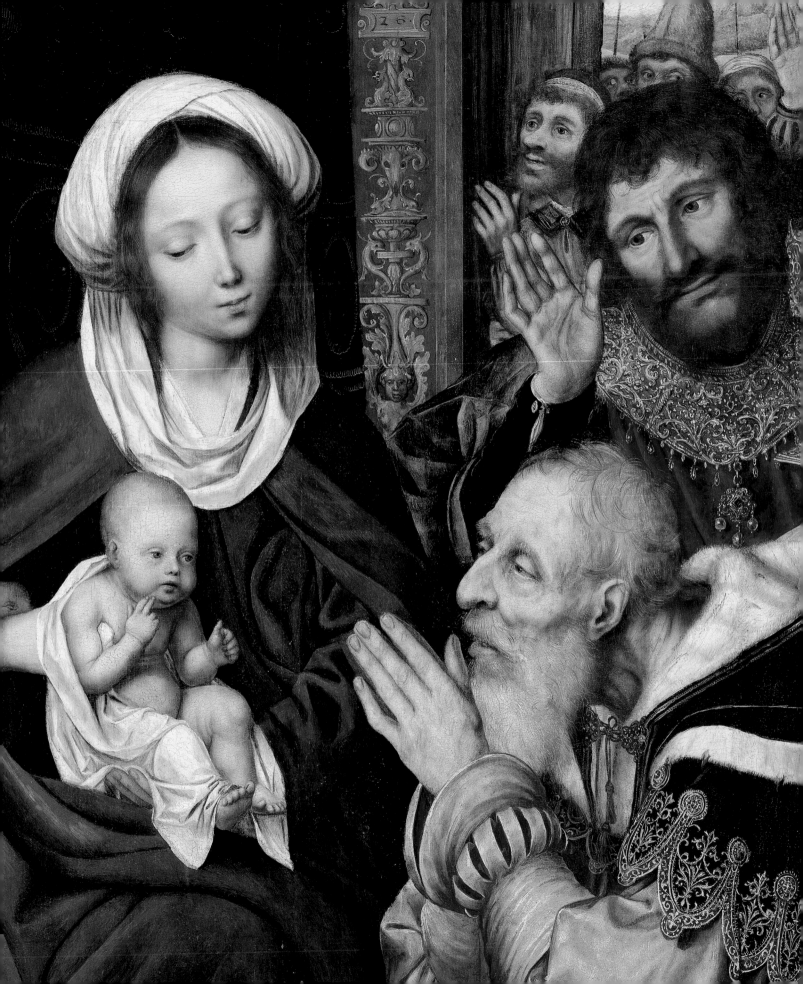

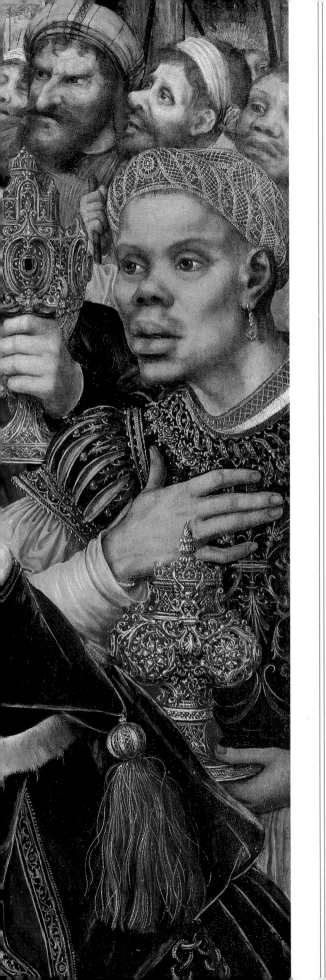

nd when they were come into the house, they saw the young child with Mary his mother, and fell down, and worshipped him; and when they had opened their treasures, they presented unto him gifts: gold, and frankincense, and myrrh.

And being warned of God in a dream that they should not return to Herod, they departed into their own country another way.

And when they were departed, behold, the angel of the Lord appeareth to Joseph in a dream, saying, Arise, and take the young child and his mother, and flee into Egypt, and be thou there until I bring thee word: for Herod will seek the young child to destroy him.

When Joseph arose, he took the young child and his mother by night, and departed into Egypt: and was there until the death of Herod: that it might be fulfilled which was spoken of the Lord by the prophet, saying, Out of Egypt have I called my son.

But when Herod was dead, behold, an angel of the Lord appeareth in a dream to Joseph in Egypt, saying, Arise, and take the young child and his mother, and go into the land of Israel: for they are dead which sought the young child's life.

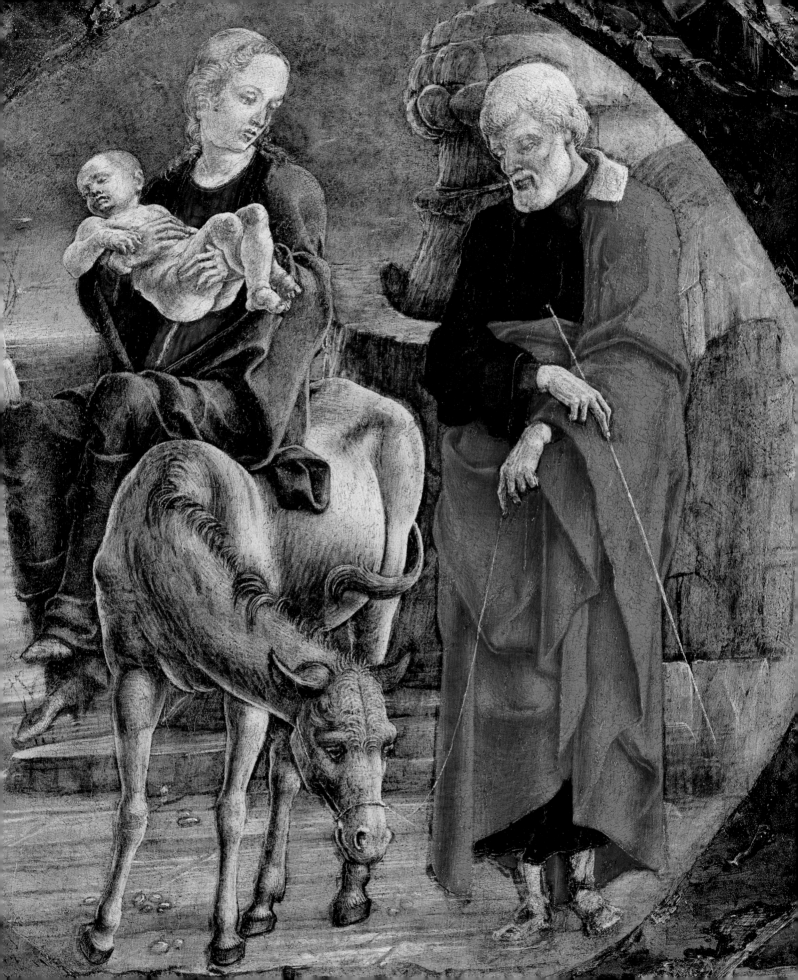

And when they had performed all things according to the law of the Lord, they returned into Galilee, to their own city Nazareth. And the child grew, and waxed strong in spirit, filled with wisdom; and the grace of God was upon him.

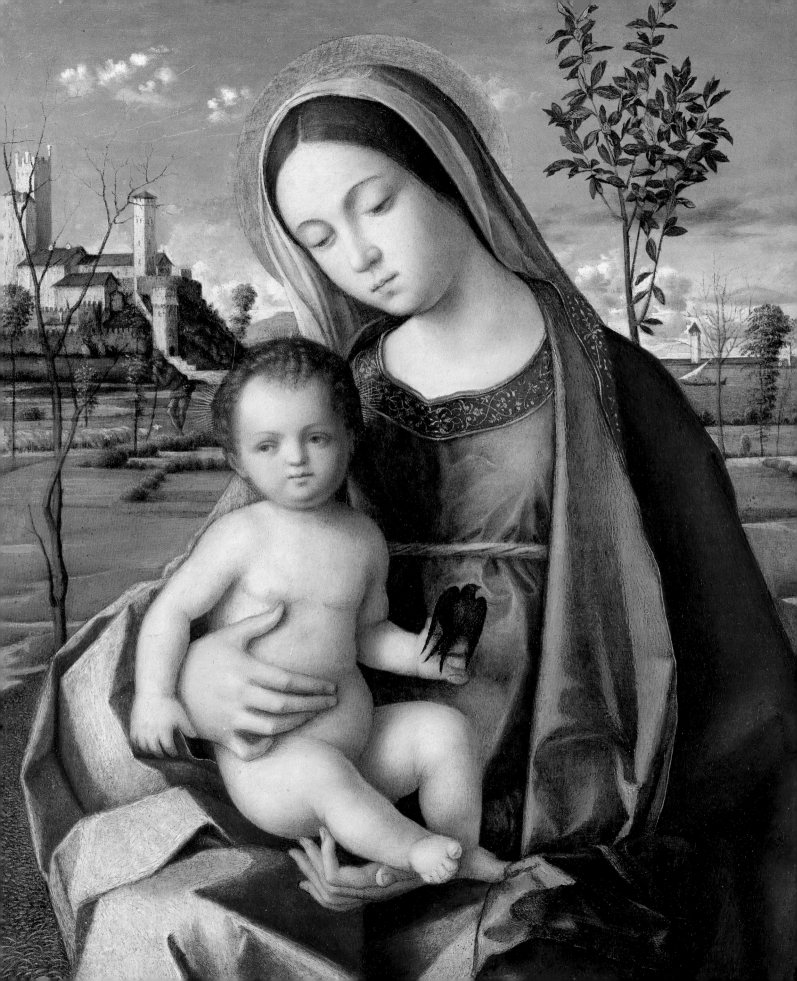

The works of art reproduced in this book are shown throughout in detail; they are shown in full on this page. All the works are from the collection of The Metropolitan Museum of Art. It is interesting to note that artists of the period often portrayed members of the Holy Family and other important biblical figures in European dress of the time. This helped make their works of art immediately accessible to contemporary audiences.

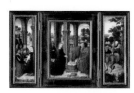

Scenes from the Life of the Virgin
Adriaen Isenbrant, Netherlandish, active by 1510, died 1551
Oil on wood, 9 ⅛ x 6 ⅞ in., after 1521
Frederick C. Hewitt Fund, 1913 13.32a

COVER AND TITLE PAGE:
The Nativity with Donors and Saints Jerome and Leonard
Gerard David, Netherlandish, ca. 1455–1523
Oil on canvas, transferred from wood,
35 ½ x 28 in., ca. 1510–15
The Jules Bache Collection, 1949 49.7.20a

Annunciation to the Shepherds
The Limbourg Brothers, Netherlandish,
active in Paris and Bourges, 1399–1416
From *The Belles Heures of Jean de France, Duc de Berry*
Ink, tempera, and gold leaf on vellum, 9 ⅜ x 6 ⅝ in., 1405–08/09
The Cloisters Collection, 1954 54.1.1 folio 52r

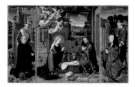

COVER BACKGROUND PATTERN, ENDPAPERS, AND JACKET FLAPS:
Tracery with birds, acanthus, oak, and holly
Daniel Hopfer, German, ca. 1470–1536
Detail from an etching; 9 ⅛ x 6 ³⁄₁₆ in.,
ca. 1510–36
Harris Brisbane Dick Fund, 1924 24.68.2

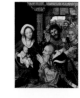

Adoration of the Shepherds
Francesco di Marco Marmitta da Parma,
Italian (Emilian), 1462/66–1505
Tempera and gold on parchment, 9 ⅝ x 6 in., ca. 1492–95
Robert Lehman Collection, 1975 1975.1.2491

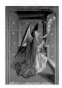

The Annunciation
Northern French Painter, life dates unknown
Oil on wood, 45 x 31 in., ca. 1450
The Friedsam Collection, Bequest of
Michael Friedsam, 1931 32.100.108

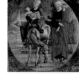

The Journey of the Magi
Sassetta (Stefano di Giovanni), Italian (Sienese),
active by 1423, died 1450
Tempera and gold on wood, 8 ½ x 11 ¾ in., ca. 1435
Maitland F. Griggs Collection, Bequest of Maitland F. Griggs, 1943 43.98.1

The Annunciation
Attributed to Petrus Christus, Netherlandish,
active by 1444, died 1475/76
Oil on wood, overall 31 x 25 ⅞ in., ca. 1450
The Friedsam Collection, Bequest of
Michael Friedsam, 1931 32.100.35

The Adoration of the Magi
Quentin Massys, Netherlandish, 1465/66–1530
Oil on wood, 40 ½ x 31 ½ in., 1526
John Stewart Kennedy Fund, 1911 11.143

The Annunciation
Hans Memling, Netherlandish, active by 1465,
died 1494
Oil on panel, transferred to canvas,
30 ⅛ x 21 ½ in., 1480–89
Robert Lehman Collection, 1975 1975.1.113

The Flight into Egypt
Cosimo Tura (Cosimo di Domenico di Bonaventura),
Italian (Ferrarese), active by 1451, died 1495
Tempera on wood, overall 15 ⅝ x 15 ⅛ in., early 1470s
The Jules Bache Collection, 1949 49.7.17

The Arrival in Bethlehem
Attributed to Master LC, Netherlandish,
active second quarter 16th century
Oil on wood, 26 ½ x 36 ⅞ in., ca. 1540
Rogers Fund, 1916 16.69

Madonna and Child
Workshop of Giovanni Bellini, Italian (Venetian),
active by 1459, died 1516
Oil on wood, overall 13 ½ x 10 ⅞ in., ca. 1510
The Jules Bache Collection, 1949 49.7.2